A Kid's Guide to Drawing™

How to Draw
Easter Symbols

Christine Webster

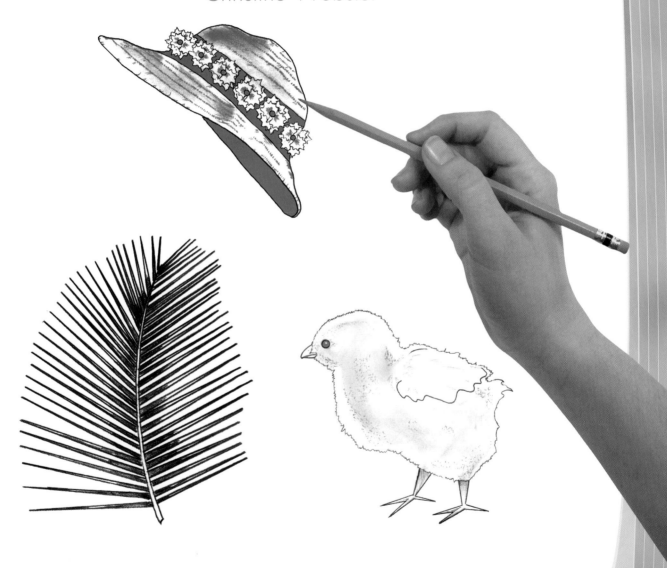

The Rosen Publishing Group's
PowerKids Press™
New York

To my husband for his continued support, and to Reverend Paul Reed for his expertise

Published in 2005 by The Rosen Publishing Group, Inc.
29 East 21st Street, New York, NY 10010

First Edition

Editor: Orli Zuravicky
Book Design: Kim Sonsky
Layout Design: Mike Donnellan

Illustration Credits: Jamie Grecco
Photo Credits: Title page (hand) by Thaddeus Harden; p. 6 © Arte & Immagini srl/CORBIS; p. 8 © Tim Davis/CORBIS; p. 10 © David Muench/CORBIS; p. 12 © Julie Habel/CORBIS; p. 14 © Royalty-Free/CORBIS; p. 16 © Ariel Skelley/CORBIS; p. 18 © Morton Beebe/CORBIS; p. 20 © Index Stock Imagery, Inc.

Library of Congress Cataloging-in-Publication Data

Webster, Christine.
How to draw Easter symbols / Christine Webster.
 v. cm. — (A kid's guide to drawing)
Includes bibliographical references and index.
Contents: Palm branch — Last Supper — Lamb — Baby chicks — Easter eggs — Easter bonnet — Easter lily — Easter bunny.
ISBN 1-4042-2726-1 (lib. bdg.)
1. Easter in art—Juvenile literature. 2. Drawing—Technique—Juvenile literature. [1. Easter in art. 2. Drawing-Technique.] I. Title. II. Series.
NC655 .W376 2003
743'.893942667—dc22

 2003015910

Manufactured in the United States of America

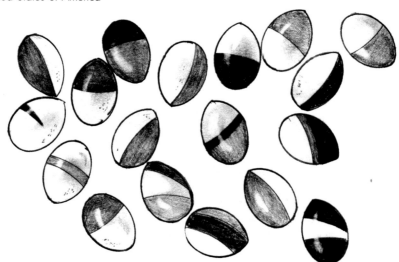

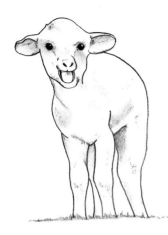

CONTENTS

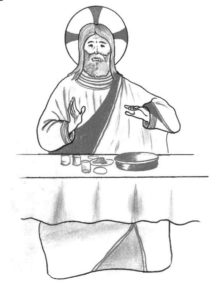

Easter Symbols

When spring comes it brings with it the **excitement** of Easter. For Christians, Easter honors the death and **celebrates** the **resurrection** of Jesus Christ. Today Easter is one of the oldest and most joyous days on the Christian calendar, but some of Easter's history goes back to a time before Christianity existed.

In ancient times, **pagans** celebrated the **Festival** of Spring, which honored Eastre, the goddess of spring and of new life. Many believe that the name Easter came from this goddess. Some of the **symbols** and **customs** honoring new life and springtime come from this ancient Festival of Spring.

The **religious** importance of Easter began about two thousand years ago with a **Jewish** man named Jesus. Jesus was a great religious leader. He had many followers who respected him, but some people felt that he was becoming too powerful. Jesus's enemies killed him, but his followers believed that he came back to life. They believed that Jesus was the Son of God, and formed a new religion based on Jesus's teachings, which they called Christianity.

Celebrations of Jesus's resurrection took place around the same time as the Festival of Spring. Over the years, the customs and symbols of the two holidays became mixed together to create today's Easter holiday. Now, as Easter nears, stores fill with candies, egg-coloring kits, and chocolate bunnies. Families gather at church for services on Easter Sunday and eat a big feast, all in celebration of this colorful holiday!

In this book, you will learn how to draw the most familiar Easter symbols. You will also learn about the history and customs of these symbols. Follow the directions carefully and use the red markings as your guide. Use the table of shapes and drawing terms on page 22 to help you. Take your time and enjoy drawing your very own Easter symbols!

The supplies you will need to draw each Easter symbol are:
- A sketch pad
- A number 2 pencil
- A pencil sharpener
- An eraser

The Last Supper

The night before he died, Jesus shared a **Passover seder** with his followers. This event is known as the Last Supper. The **New Testament** says that Jesus told his followers that night that one of them would **betray** him, and that in turn Jesus would die. During the meal, Jesus compared the broken bread to his body, and the drinking wine to his blood. He told his followers to continue to break the bread and to drink the wine in his memory. The next day Jesus was killed.

Today most churches break bread and drink wine during their services. Families often celebrate Easter with a large feast of lamb, wine, and prayers in honor of Jesus's Last Supper.

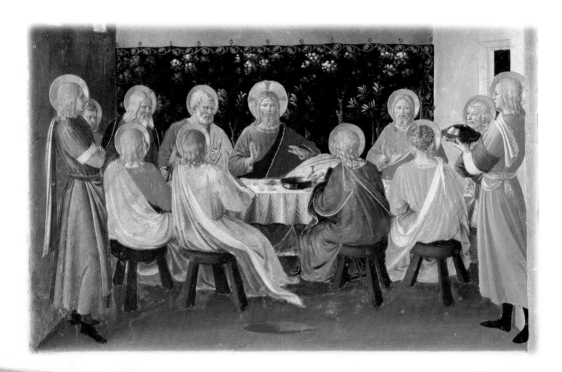

1

Draw two circles. One is for Jesus's head and the other for his halo. A halo is a circle of light that is used to show a person's closeness to God.

2

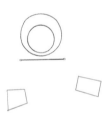

Add a straight line under the big circle. Draw a tiny circle on each end. These will guide the shape for his shoulders.

3

Add two rectangular shapes, as shown. These shapes will be the bottom of Jesus's sleeves.

4

Draw two shapes for Jesus's hands, in the positions shown. Under them, draw three horizontal lines. These will be used for the table.

5

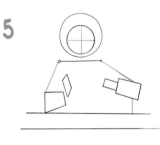

Add straight lines to connect Jesus's body. Draw three lines to form a rectangle beneath the third horizontal line. Draw two lines inside the inner circle as a guide for later.

6

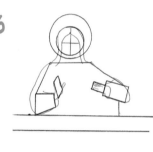

Use the shapes and lines as your guide to shape Jesus's body. Do this to the bottom rectangle as well. This is Jesus's robe. Draw his hair and hands.

7

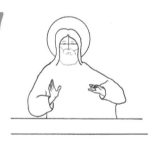

Erase any extra lines. Draw in Jesus's face using the lines as guides for where the eyes and the nose should go. Then add a wavy line for his beard.

8

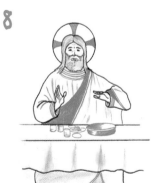

Great! Now shade in Jesus any way you like. You can even draw some food on the seder table.

The Lamb

The lamb is an important Easter symbol. It stands for **innocence** and **sacrifice**. For Christians, it also stands for Jesus. In ancient times, the lamb was considered the meekest animal and was often killed for the gods. Christians believe that Jesus offered himself to God to take away the sins of the world through his death. Like the lamb, Jesus was innocent. Christians also call Jesus the Good **Shepherd**. They believe that he watches over them the way a shepherd watches over his sheep.

Jesus ate lamb at the Last Supper that he shared with his followers. Today Christians serve lamb at their Easter feasts. The lamb reminds them of Jesus's innocence and the sacrifice that he made for their sins. Cakes baked in the shape of lambs are also a familiar Easter treat.

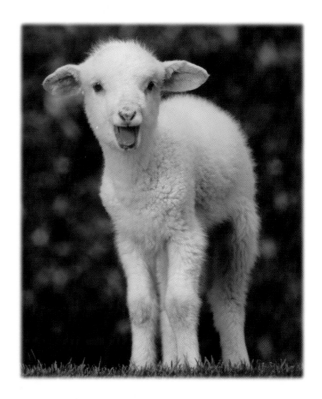

1

Draw three circles. The top one will be the head of the lamb. The other two will be guides for the lamb's body. Notice the sizes and positions of the circles.

2

Under the three circles, draw two smaller circles next to each other. These will be the lamb's knees.

3

Draw shapes for the lamb's two front legs. The knees should fall in the middle of each leg.

4

Add two curved lines, one on either side of the head, for the lamb's ears.

5

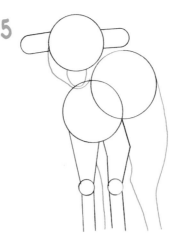

Draw the lamb's back legs using three lines. Add the bottom of its face with two curved lines.

6

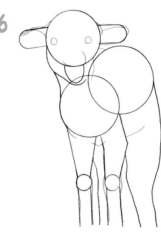

Add extra lines to the lamb's body, as shown in red. Finish the ears and the mouth. Add two small circles for the eyes.

7

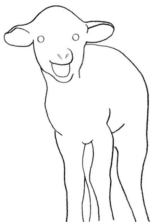

Erase any extra lines and add two small lines to create a nose.

8

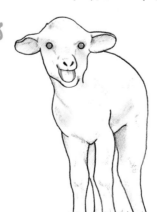

Your lamb looks great! Now shade in your lamb and you are all done!

9

The Palm Branch

In ancient Rome, it was a custom for townsfolk to welcome royalty by waving long palm branches in the air. When Jesus rode his donkey into the town of Jerusalem for the Last Supper, his followers welcomed him by waving palm branches in the air and by covering the streets with palms in celebration.

Christians see the palm branch as a symbol of Jesus's **victory** over death. This victory is his resurrection. Palm Sunday marks the beginning of the last week of Jesus's life. In his honor, Christians carry palm branches in parades. They also make palm leaves into crosses and **garlands**, which they use to decorate their churches and homes in celebration of his life.

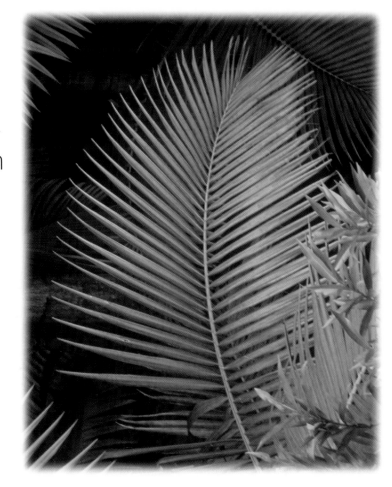

1

Draw two vertical, curved lines and connect them at each end. These lines will be the stem of the palm branch.

2

Draw two more curved lines on either side of the center of the palm as shown. These lines mark how wide the branch will be.

3

Draw small dots at the top and along the outer lines. These dots will mark where the tips of the palm leaves will be.

4

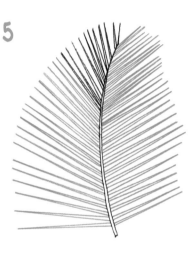

Draw thin, upside-down V shapes from the center line to each dot that you have made to create the palm's leaves. The points of the V shapes should connect to the dots.

5

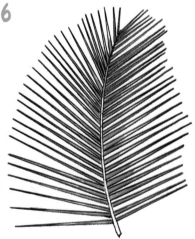

Finish filling in the palm branch this way. Make as many leaves as you want. The branch's sides do not have to be equal. Now erase the guidelines.

6

Add shading and you are finished!

Baby Chicks

Baby chicks **hatch** every spring, right around Easter time. As spring does, baby chicks **represent** the beauty of new life and nature. Since Easter is also a celebration of new life, the baby chick has become an important symbol of the Easter holiday. After a long winter, watching a baby chick hatch out of something as lifeless as an egg brings the hope of new beginnings. For Christians, the baby chick also stands for Jesus. The egg represents the grave from which Jesus is said to have risen. To Christians, a little chick breaking out of its shell represents Jesus breaking out of his grave. Today pictures of baby chicks decorate homes and stores during the Easter season. Chocolate and candy chicks are eaten as sweet Easter treats! Baby chicks are also given as pets on Easter.

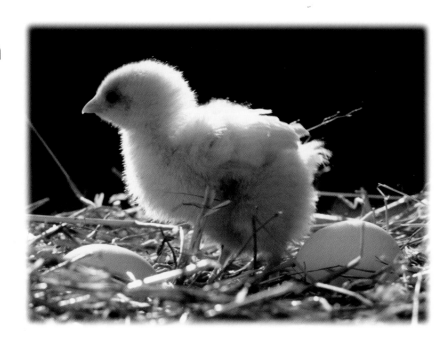

1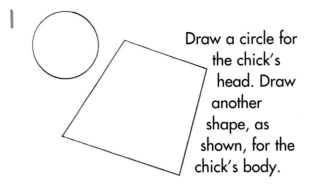

Draw a circle for the chick's head. Draw another shape, as shown, for the chick's body.

2

Draw a sideways V shape coming out of the left side of the circle for the chick's beak. Draw a triangle, with one point positioned as shown, inside the chick's body for its wing.

3

Connect the body and the head with two curved lines. Add two V-shaped lines to the body for its legs.

4

Add three thin V shapes to each leg as shown. These will be the chick's feet.

5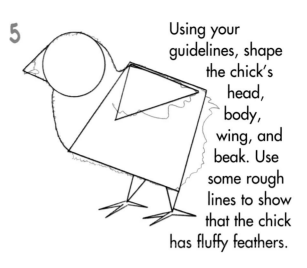

Using your guidelines, shape the chick's head, body, wing, and beak. Use some rough lines to show that the chick has fluffy feathers.

6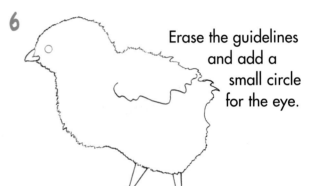

Erase the guidelines and add a small circle for the eye.

7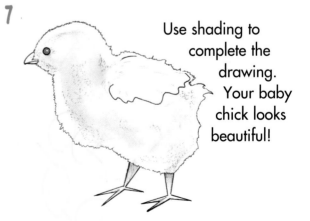

Use shading to complete the drawing. Your baby chick looks beautiful!

13

Easter Eggs

Ancient Egyptians believed the world began with a single egg. The Egyptians and other ancient **cultures** colored eggs during spring festivals. In the Middle Ages, English royalty gave one another gold-covered eggs as Easter gifts. Today people use markers, food coloring, and paints to decorate hard-boiled eggs with the beautiful colors of springtime.

For Christians the egg is a symbol of Jesus's grave. Egg rolling is a popular Easter game that represents the rolling away of the rock that was placed in front of Jesus's grave. Egg-rolling contests have taken place on the White House lawn every year since 1878. Decorating Easter eggs and having egg hunts and egg-rolling contests are all part of the fun of Easter!

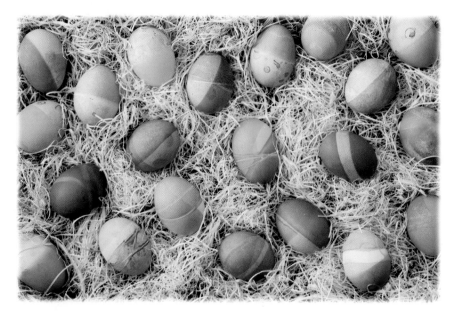

1

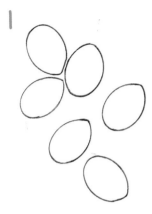

To create the basic shape of the eggs, start by drawing six ovals. Make one end of each oval a little pointier than the other.

2

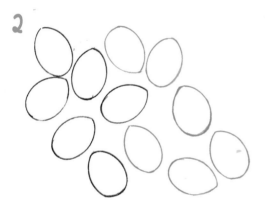

Now, draw six more ovals, the same way you drew the ones in step 1. These will also be eggs.

3

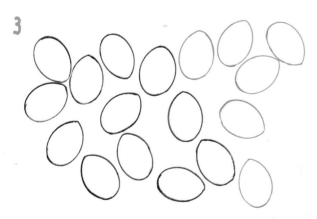

You are really getting the hang of it now! Add six more ovals. You should have 18 eggs in all.

4

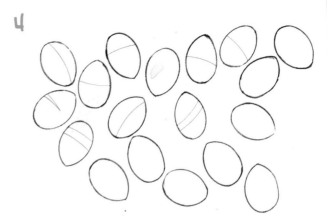

Draw some curved lines across half of the eggs as guidelines for their coloring marks.

5

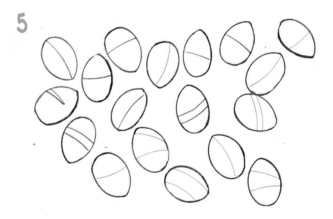

Add more curved lines, as shown, to the rest of the eggs for their coloring marks.

6

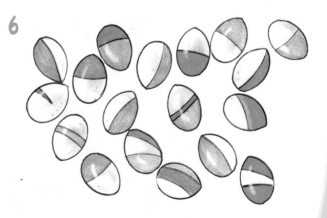

Now shade in your eggs. Add whatever decorations you want, like flowers or polka dots. You can even write your name!

The Easter Bonnet

The custom of wearing new bonnets at Easter began with a Christian service called a **baptism**. During baptisms, Christians wore white robes and bonnets to represent the new life and faith that Jesus's resurrection gave them. At first, the robes and bonnets were worn only during new baptisms, but the custom quickly spread to all who wanted to celebrate spring and new life. By the time Easter came and announced spring, people were tired of wearing heavy winter clothes. They celebrated by wearing new, lighter clothing, which often included a beautiful Easter bonnet, decorated with flowers, **ribbons**, and **lace**. People walked to church, showing off their beautiful new hats. This is how the Easter parade began.

1 Draw a half circle for the top of the hat. Notice its position. Now draw a shape, as shown, for the brim, or bottom, of the hat.

2 Using those lines as guides, shape the bonnet with wavier lines. Notice the oval loop on the right side of the brim.

3 Erase the outlines of the original two shapes.

4 Draw a curved line across the center of the hat. You will use the line as a guide for drawing the bonnet's flowers.

5 Draw a circle in the center of the line. It will be the center of a flower. Draw in some petals, or parts of the flower, as shown.

6 That looks great! Now repeat step 5 and draw another flower.

7 Continue to add flowers. Add two curved lines, one above the center line and one below. Some of the top line is hidden behind the flowers.

8 Erase any extra lines. Add shading to your bonnet and you are all done!

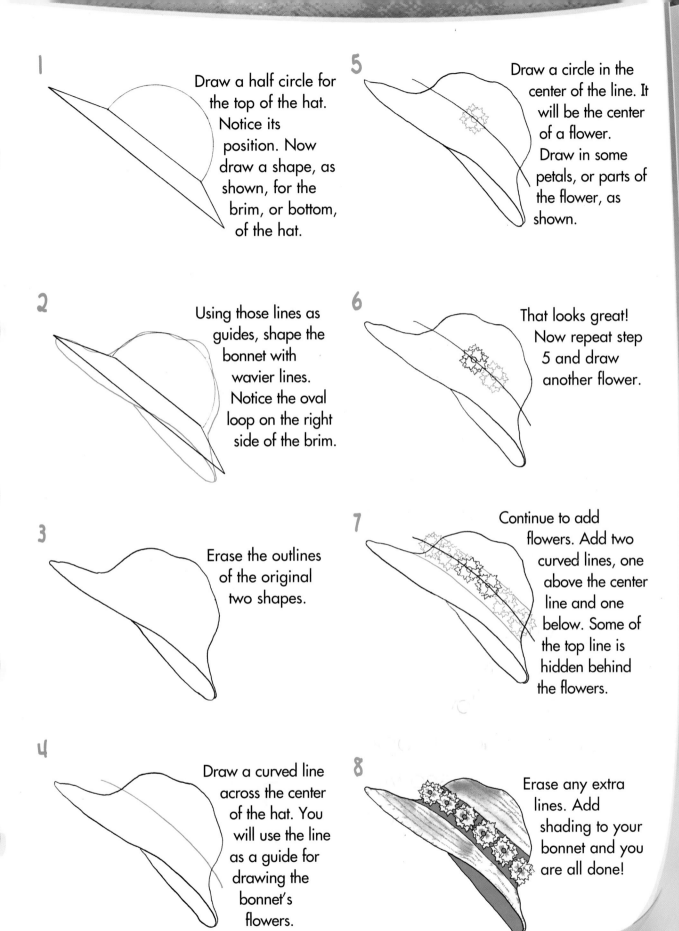

The Easter Lily

Since the late 1800s, the white lily has decorated homes and churches at Easter time. The pretty white lily reminds Christians of purity. It is a symbol of the hope that Jesus brought to his people through his resurrection. The lily begins in the ground as a hard, brown bulb, and, every spring, it **blooms** into a beautiful flower. Its shape is like that of the trumpet, an instrument used to announce victory.

One story says that when Jesus walked the earth, all of the living things, except the lily, bowed their heads in respect. The lily grew straight up, its bloom facing the sky, and was too proud to bow down. According to the story, after Jesus died, the lily felt so bad that it too bowed its head and continues to do so as a sign of everlasting respect to Jesus.

1

Draw a large rectangular shape as a guide for the flower's biggest petal.

2

Draw a V shape coming out of the right side of the rectangular shape. Notice where the lines touch.

3

Draw two triangles as shown. Notice how one point of each triangle crosses over the rectangular shape.

4

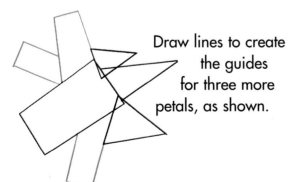

Draw lines to create the guides for three more petals, as shown.

5

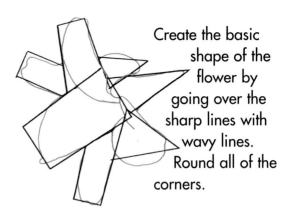

Create the basic shape of the flower by going over the sharp lines with wavy lines. Round all of the corners.

6

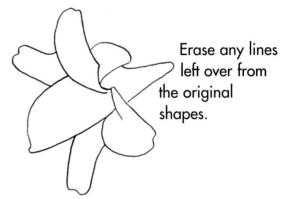

Erase any lines left over from the original shapes.

7

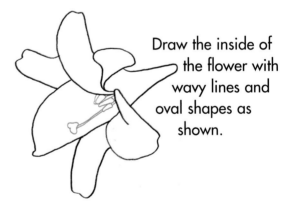

Draw the inside of the flower with wavy lines and oval shapes as shown.

8

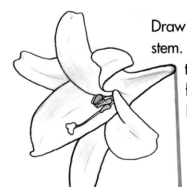

Draw a line for the stem. Add shading to complete the flower. Your Easter lily looks great!

The Easter Bunny

The Easter bunny is a big part of the Easter celebration today. The bunny rabbit has been a symbol of new life and spring festivals since ancient times. In a story from the 1700s, a poor German woman had no money to buy her children Easter gifts. Instead, she hid colored eggs in her garden as Easter treats. Upon spotting the eggs, the children saw a bunny hop past and thought that it had left the eggs. German children began to make nests for the Easter bunny, in hopes that it would lay more beautifully colored eggs!

Today pictures of the Easter bunny decorate homes, baskets, and cards during Easter. Chocolate bunnies line store shelves and fill the mouths of people all over!

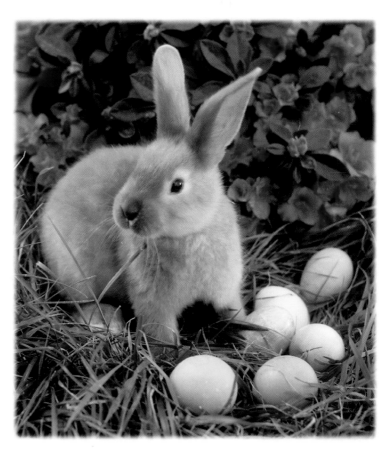

1 Draw two overlapping circles. Make the circle on the right bigger than the one on the left. These will be the guides to help you draw the rabbit's head.

2 Draw a bigger circle, to the left of the small one, for the body. Part of this circle will be hidden underneath the smaller circle. Add another small circle under the second big circle for the rabbit's foot.

3 Draw two straight lines as shown. Draw three more straight lines inside the two big lines, as shown, to create the shape of the front legs.

4 Add two rectangular shapes coming out of the rabbit's head. Add a triangle to the smaller shape. These will be the ears.

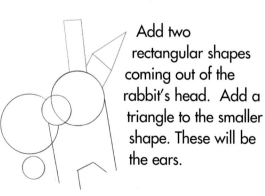

5 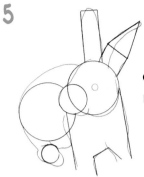 Using your guides, create the shape of the rabbit. Round the rabbit's nose, ears, and feet as well. Now add a small circle for the eye.

6 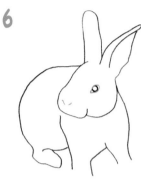 Erase extra lines and use the circle as a guide for the shape of the eye. Finish the nose by making two small marks as shown.

7 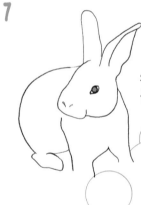 Shade in the eye. Add some oval shapes at the feet to create some eggs. Look back at page 15 for help drawing and shading the Easter eggs.

8 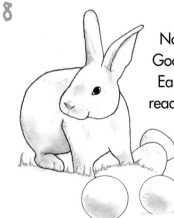 Now add shading. Good job! Now your Easter bunny is ready to go!

Drawing Terms

Here are some words and shapes you will need to draw the Easter symbols:

○ circle

∿ curved

— horizontal

⬭ oval

▭ rectangle

✎ shading

□ square

△ triangle

| vertical

〰 wavy

Glossary

baptism (BAP-tih-zum) A ceremony done when someone accepts the
 Christian faith, intended to cleanse a person of his or her sins.

betray (bee-TRAY) Turn against.

blooms (BLOOMZ) Has flowers.

celebrates (SEH-luh-brayts) Observes an important occasion with special
 activities.

cultures (KUL-churz) The beliefs, practices, and arts of groups of people.

customs (KUS-tumz) Practices common to many people in an area or a
 social class.

excitement (ik-SYT-ment) The state of being happy or overjoyed.

festival (FES-tih-vul) A day or special time of rejoicing or feasting.

garlands (GAR-landz) Circles of flowers or leaves.

hatch (HACH) To come out of an egg.

innocence (IH-nuh-sens) Having done nothing wrong.

Jewish (JOO-ish) Referring to the faith of Judaism, which is based on the
 teachings of the Torah, or Jewish Bible.

lace (LAYS) A piece of material that is used for decoration.

New Testament (NOO TES-teh-ment) The second part of the Christian Bible
 containing the life and teachings of Jesus Christ.

pagans (PAY-gunz) People who believe in more than one god.

Passover (PAS-oh-ver) A Jewish holiday that remembers the Jews' freedom
 from slavery in the land of Egypt.

religious (ree-LIH-jus) Faithful to a religion and its beliefs.

represent (reh-prih-ZENT) To stand for.

resurrection (reh-zuh-REK-shun) Coming back to life after dying.

ribbons (RIH-benz) Flat and narrow pieces of material that are tied to hold
 something together, usually used for decoration.

sacrifice (SA-krih-fys) Something that has been given up for a belief.

seder (SAY-dur) A special dinner and service held by Jews during the first
 two days of Passover.

shepherd (SHEH-perd) A person in charge of a flock of sheep.

symbols (SIM-bulz) Objects or pictures that stand for other things.

victory (VIK-tuh-ree) The winning of a battle or a contest.

Index

Web Sites

Due to the changing nature of Internet links, PowerKids Press has developed an online list of Web sites related to the subject of this book. This site is updated regularly. Please use this link to access the list:

www.powerkidslinks.com/kgd/eastsym/